Characters

Paintings, drawings and sketches

Characters

Paintings, drawings and sketches
by Antony Sher

N
H
B

Nick Hern Books
a division of Walker Books Limited

Characters first published in 1989 by Nick Hern Books,
a division of Walker Books Limited,
87 Vauxhall Walk, London SE11 5HJ

British Library Cataloguing in Publication Data
Sher, Antony, 1949-
Characters.
1. English graphic arts. Sher, Antony, 1949-
I. Title
760'.092'4

ISBN 1-85459-031-6 Hardback
ISBN 1-85459-032-4 Paperback
Printed and bound by Olivotto, Italy

For Jo

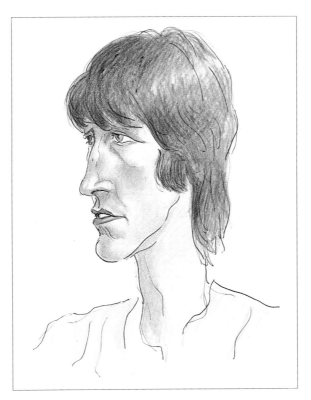

'Georgina (Jo) Jelly',
ink and coloured pencils, 1979

Preface

I was tremendously excited when Nick Hern suggested a book of my paintings and drawings. At last – all those childhood dreams of being an artist – at last, recognition! But then I began to have second thoughts. Wouldn't the book be misleading? I'm not an artist. I've illustrated the books I've written, sketched some of the characters I've played, and I paint in my spare-time. Looking over my work, I found posters, book jackets, sketches from scripts, and dozens of paintings and drawings on subjects which preoccupy me; like the theatre, gay life, South Africa, etc. So Nick and I decided that instead of an 'artbook', we'd aim for something more informal – a sketchbook, a scrapbook, an album …

My parents say that I started drawing at the age of four. Certainly some of my earliest memories are of lying on the bedroom floor, surrounded by drawing paper. I remember the sensation of time passing at remarkable speed, and of myself somehow disappearing in the rush, overjoyed. I suppose this same joy, a joy of losing myself, was later to make acting attractive.

I was an intensely shy child born into quite the wrong society: mid-century South Africa. It wasn't yet the politics which made me uncomfortable; it was the persona of people around me: a kind of easy-going, outdoor swagger. Luckily drawing came to the rescue. My skill with a pencil provided some compensation for my failure with the rugby ball, and when the art master at school arranged for me to spend gym periods in the art room, my commitment to a lifetime of painting was sealed.

The art master was a Scot, John McCabe, a hefty, bushy-browed man with the longest thumbnails I'd ever seen. I was quickly drawn to his irreverent British wit, and to the way his enthusiasm and criticism were delivered in equal dollops. 'No, no, Sher', he'd say, 'now you've gone and put a woman's chest on that man. Can you not inform your precocious wee fingers that the lines of the female are rounded, while the male's are squared off? Stop pouring over Michelangelo's stuff – he never got his bloody anatomy sorted out!' Michelangelo was my great hero, followed closely by Mort Drucker of Mad Magazine. I worshipped the former for the passion and

athleticism of his figures, as well as their mysterious sexiness; and the latter for his brilliant caricatures of movie-stars.

Now permanently excused from gym, I began to enjoy my schooldays. My cartoons were popular in the school magazine, and the annual exhibition brought new rewards: extra pocket-money ('Sold a water-colour for 15/6d', I boast in my 1963 diary) and, better still, fame. 'Cape boy of 14 is WONDER ARTIST!' announced the local paper. Since this was a society where you believed everything you read in the papers, the family suddenly developed new respect for the bespectacled wimp among them. And when my parents printed my drawing of 'The Deluge' on our Rosh Ha-Shanah card the next year, my status soared still higher. On the graph of fame there was only one stage further to go: the fall.

In my penultimate school year, another boy in my class unexpectedly sprang to the fore. His name is branded on my memory. Bishop. He sold more pictures than me at the exhibition, and then won a local drawing competition, while I got a consolation prize! I was distraught. A has-been at sixteen.

The collapse of my art career happened, fortunately, to coincide with an increasing pleasure in Auntie Esther's Elocution classes and some success at the local drama Eisteddfod. Then I scored a hit in the school play, the Whitehall farce *Simple Spymen*, and my reputation was partially restored. Except that acting seemed a lesser art form. It was interpretative, not truly creative, you needed the writer's words first. A playwright! Perhaps that's what I should be? I was very confused.

Discussing it with my parents, we agreed to abandon our original plan: Art School in Italy (Why Italy? How would I have understood my tutors?); and since you couldn't really train to be a playwright, perhaps Drama School in London was the only decent thing left. My parents remained calm and supportive throughout, but other members of the family were less restrained: 'You're not going to Art School? Your acting, it's alright, no offence, but your drawing – that Rosh Ha-Shanah card you sent us, with all the people drowning, that was damn fantastic man, and you want to go to Acting School?'

As for Mr. McCabe, I couldn't bring myself to tell him. But of course he found out, and his reaction was very shocking. He stopped speaking to me altogether. Overnight, I ceased to exist. Looking

back now, I wonder if his hopes for my career stemmed from some disappointment in his own; I don't know – at the time I was aware only of losing a great friend and mentor, and felt even less sure of where I was going.

Acting proved to be far more challenging and creative than I had anticipated, and for the next fifteen years painting and drawing stayed in the background, as did any thoughts of being a writer. Things changed in 1983. Antony Harwood, then an editor at Chatto and Windus, asked if I'd like to write and illustrate a book about the next part I played. That book, *Year of the King*, was very satisfying to do, and when it was followed by an exhibition of the artwork, it somehow laid to rest all those adolescent conflicts: whether to be an actor, artist or writer.

However, moving into new areas also brought a sense of danger, of trespassing. There's a peculiarly British stricture which demands that you stick to what you know, and to what others know you for. But of course the creative arts should, and do, mix fruitfully. The theatre director without a painter's eye for composition will be the poorer for it, as will the playwright without a composer's ear for rhythm and melody. Cocteau describes this inter-mingling beautifully: 'Writing for me is drawing. Tying the lines together in such a way that they make writing, or undoing them in such a way that the writing becomes drawing.'

The actor also battles with lines: the lines which the playwright has written, and the outlines of the new personality he is to inhabit. When character-acting operates at its best, like Olivier in *Othello*, Brando in *The Godfather*, Meryl Streep in *Sophie's Choice*, then it can become a remarkable creative process. The actor uses his body almost like paint or clay, to make an utterly different shape, with a different weight, a different motion, producing a different sound.

I've always been fascinated by people. Landscapes or still-life hold little interest for me, and when they occur on these pages it is only because of their human resemblance, like the mountain on page 38 or the shoes on page 84.

How accurate should portraiture be? I keep changing my mind. Sometimes it is satisfying to try and capture a resemblance very precisely: as in the double portrait of my mother (page 35), with and without make-up, rather like an actress. This was done from life

during several sittings, and then backed up with reference photographs. Or the sketches of actors in rehearsal (pages 20, 74-5, 82); here again I'm aiming for a resemblance, albeit exaggerated, caricatured. At other times I enjoy drawing people from memory, just a very subjective impression, usually after meeting them for the first time, like Pinter (page 45), and Fugard (pages 44 and 86). Or sometimes, coming home after a great visit to the theatre, I try and record some sensation of the performance; the Rustavelli Richard III (page 16) or Judi Dench's Mother Courage (page 43).

The only self-portraits I do are of favourite roles. Sketching them during rehearsals helps clarify the character; but then, painting them afterwards, it becomes more an impression of what it felt like playing the role, or how ideally I'd have wished to look. *If only* my body could've been as scrunched as the Fool on page 23; *if only* I could've been as dishy as Howard Kirk on page 3; and so on. The artist in me always taunts the actor for falling short.

But in this messy, sometimes frustrating way, they have come together: the different possibilities which so tempted, so confused me as a teenager.

After I left South Africa in 1968, I lost touch with John McCabe, art master at Sea Point Boys' High School, and we didn't meet again until 1976, during my first visit home. I had by then appeared in *John, Paul, George, Ringo and Bert* in the West End, but he made no mention of it. We found little to say to one another. I remember him asking if I was doing any painting, and me answering, 'Now and then.' He died unexpectedly a few months later, so he was never to know that my artwork would eventually see the light of day. Perhaps not quite as he had imagined, not quite adorning the art galleries of the world, but nevertheless reproduced very flatteringly by Chatto and Windus in the two books I've done for them, and now here by Nick Hern Books. I'd have loved to send these to him, with a note of thanks. But I expect he would've just written back complaining that Tartuffe's bum (page 33) was too feminine and asking when was I going to start getting my 'bloody anatomy sorted out'?

London, 1989.

AUTHOR'S NOTE

Apart from the hand-written passages, the rest of the text accompanying
the pictures is drawn from work which I've published:

Year of the King (Chatto and Windus, 1985), a diary and sketchbook of the
year when I was preparing Richard III for the Royal Shakespeare Company.

Middlepost (Chatto and Windus, 1988), a novel based on my family
history, which follows the journey of Smous, a Lithuanian Jew, as he flees
to British South Africa in 1902 and travels inland to the isolated
settlement of Middlepost.

South Africa's Chosen People (The Guardian, September 1988), an article
on the background to *Middlepost.*

'The Fool in King Lear' from *Players of Shakespeare*, 2 (Cambridge University
Press, 1988), an essay on playing the Fool in the 1982 Royal Shakespeare
Company production.

Richard III in Australia (The Times, July 1986), a diary of the
Royal Shakespeare Company tour.

Hello and Goodbye (The Times, August 1988), a diary of the Royal Shakespeare
Company production at the Almeida Theatre.

I would like to thank Chatto and Windus for their co-operation on this book.

List of Characters

Characters

'Jeu de Paume', 1983

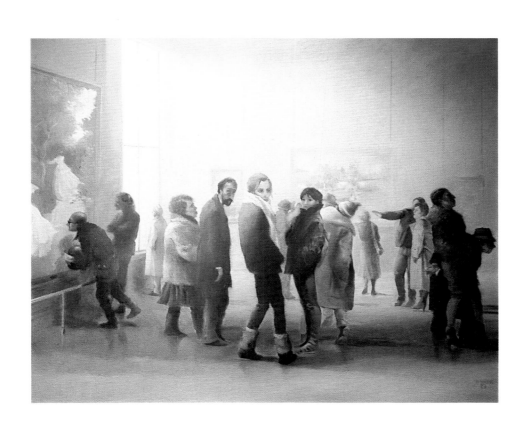

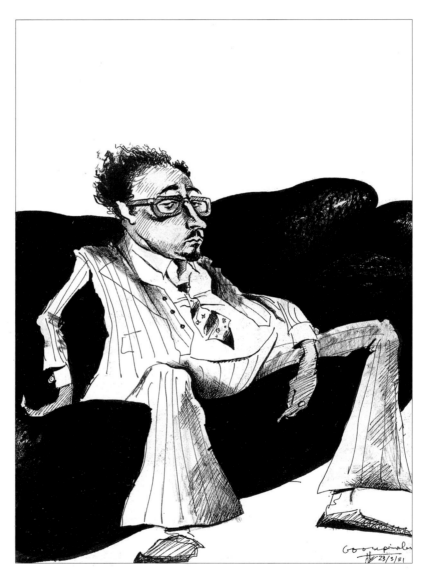

'Goose-Pimples', 1981

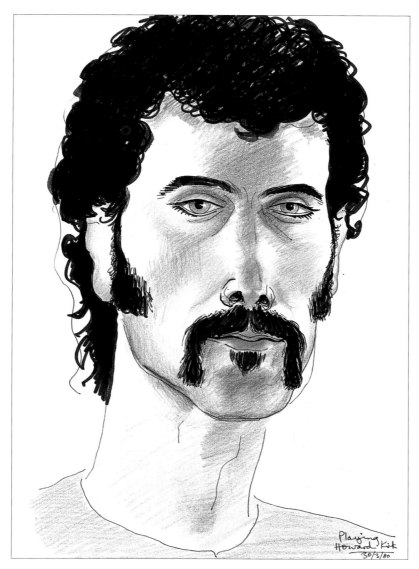

'Playing Howard Kirk' (The History Man), 1980

My parents are first generation South Africans (their parents were from Lithuania and Russia). They met in Cape Town, where they married in 1941, but both had been raised in rural areas : my father in Middlepost and Calvinia, on the baking plains of the Karoo ; my mother in Montagu, a pretty valley town, surrounded by orchards and vineyards. There is something of those early environments in their characters. The unchanging Karoo landscape has left my father with a liking for simple, practical things, an impatience with Sundays or holidays, a dedication to work — he runs a firm which exports raw skins and hides. My mother runs the family, and fills her free time with gardening, yoga classes, spiritualist meetings, shopping expeditions, trips to the theatre and cinema. I am the third of their four children.

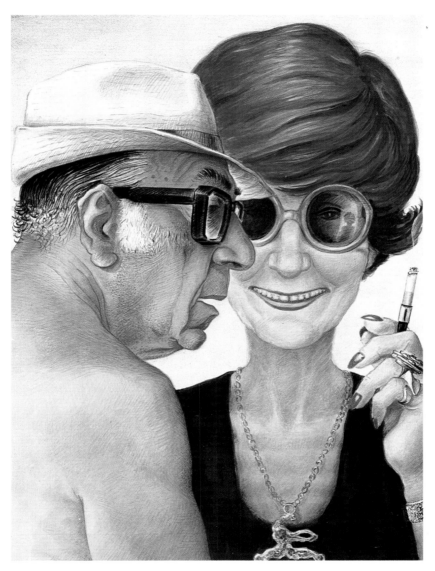

'My Parents', 1977

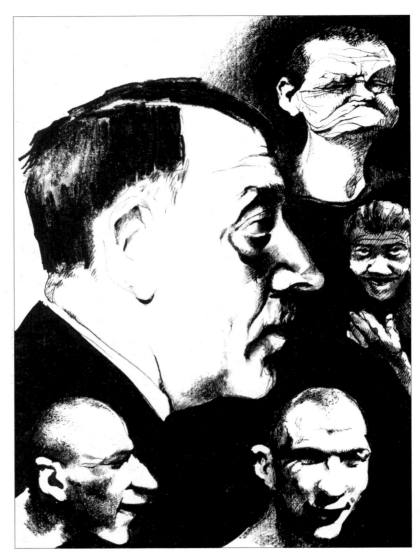

'Hitler and the Mentally Ill', 1984

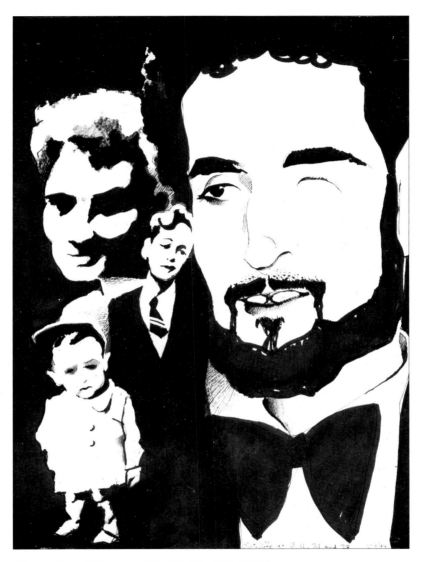

'Peter Sutcliffe, aged 3, 11, 21, 28', 1984

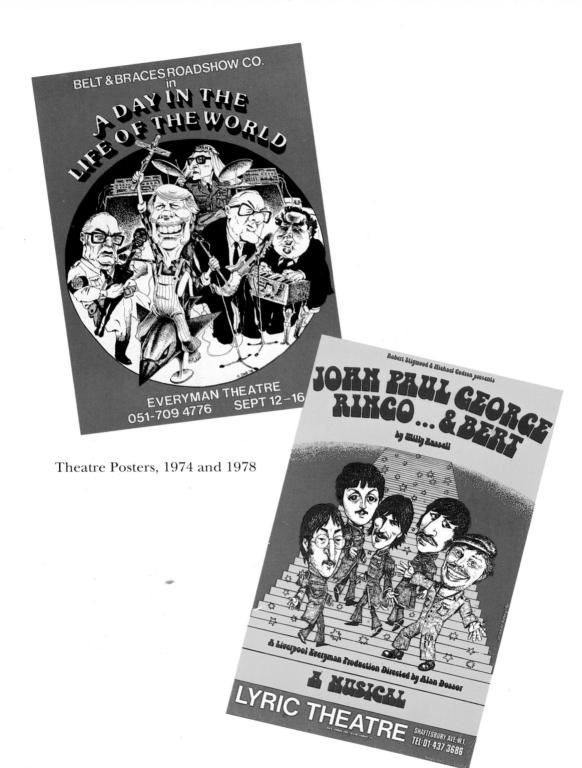

Theatre Posters, 1974 and 1978

8

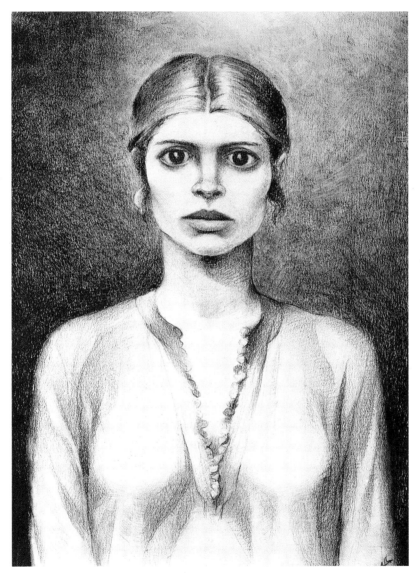

'Barre', 1971

When I first met the Hooper twins in 1973 I was struck by how little they looked like twins, hardly like brothers, and yet their relationship was very particular. I've tried to paint those early impressions: their intense bond, the dominance of the older twin, Bob (on the right). They're both actors, so I've painted make-up on their hands and faces. The zebra skin is South African and used to be on the floor of my bedsit in Belgrave Gardens, where they're sitting. Over the years I've continued to sketch them, but mostly separately. In this book there's one more of Bob, and several of Jim, with whom I live: "Watching Juno", "Actor Resting", "The Sketch", "The Nap" and one or two others.

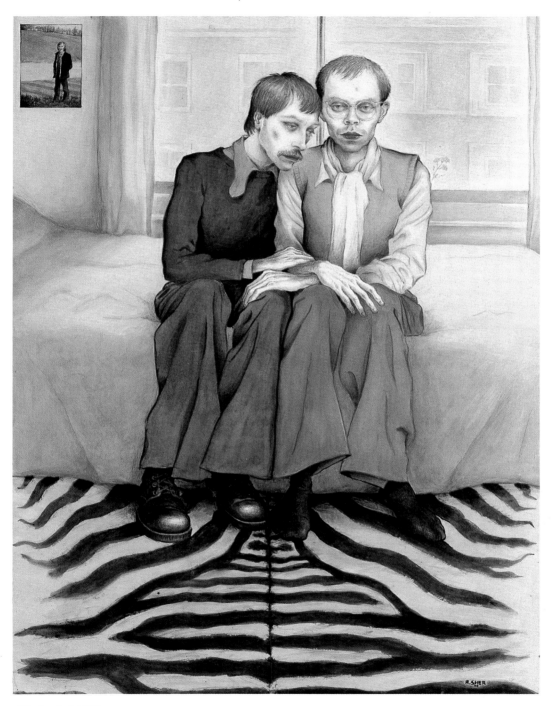

'Twins', 1975

'Drying Out', 1979

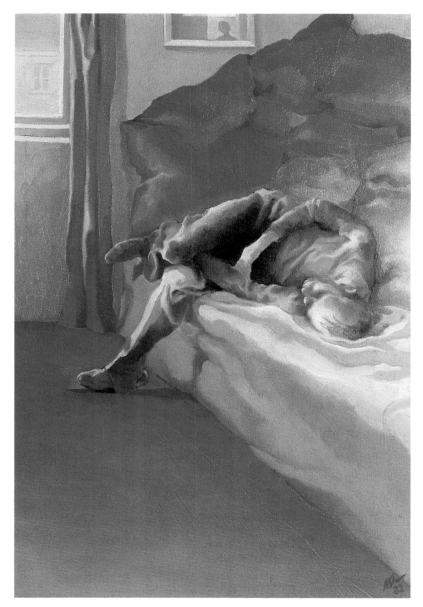

'Actor Resting', 1982

I can't remember who suggested I should design and paint a huge backcloth for Chris Bond's 1974 version of "The Country Wife" at the Liverpool Everyman, or why they should've asked me, since I'd never done anything along those lines before. I expect the reason was economical — I don't think I was paid. But I do remember three very happy nights, working from about 11 pm to 10 am, then sleeping during the day. There were no sketches for the painting, no preparation time, so the thing just kept on spreading, exploding. I wonder where it is now.

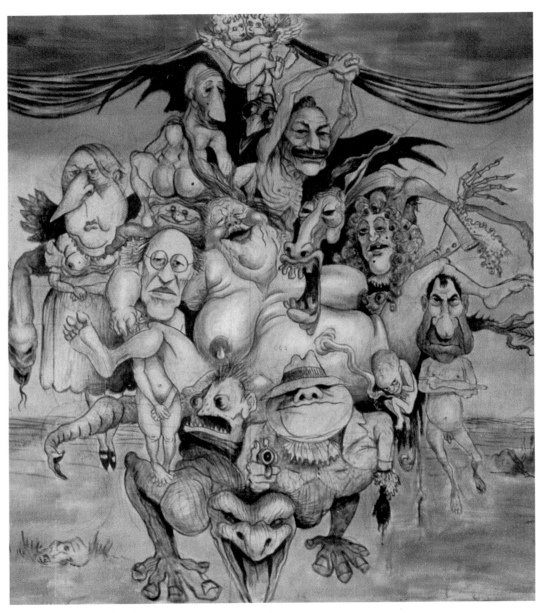

Backcloth for *The Country Wife*, Liverpool Everyman, 1974

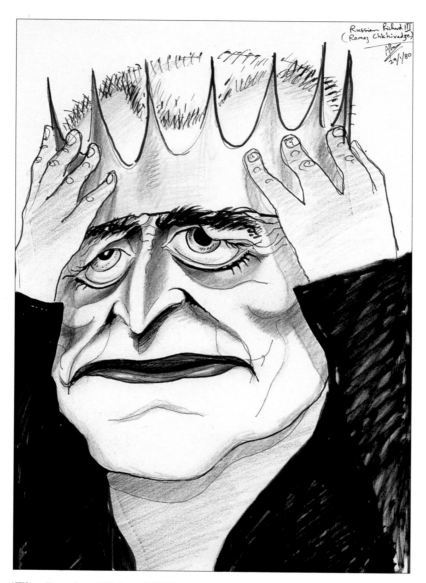

'The Russian Richard III'
(Ramaz Chkhivadze in the Rustavelli Production), 1988

Richard III has not entered my thoughts for two weeks now, but did in a dream one night. Olivier's face in extreme close-up. Viewing it in a slow circle, closer and closer, till I realise it's not on a cinema screen as I thought, nor carved on the side of a mountain as it next appears, but it's actually *there*. Circling the giant. Closer and closer it comes …
From *Year of the King*.

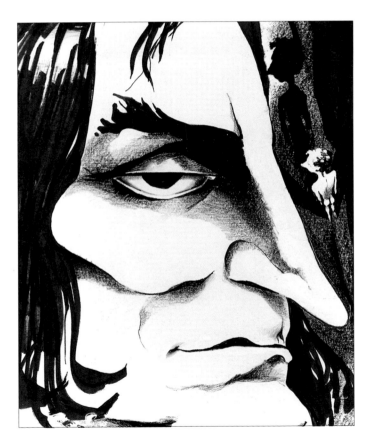

'Olivier's Richard III' (in a dream), 1984

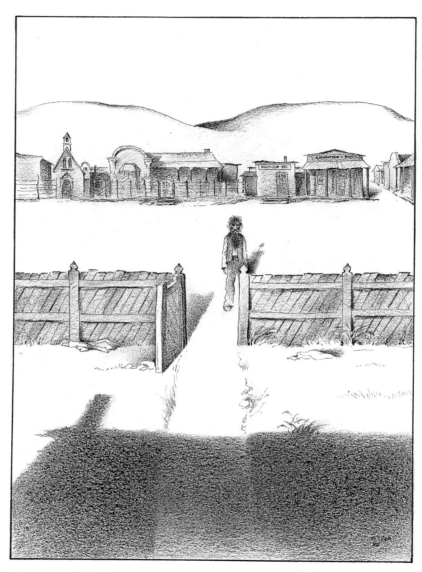

'Calvinia', 1988

'Dad at Belgrave Gardens', 1979

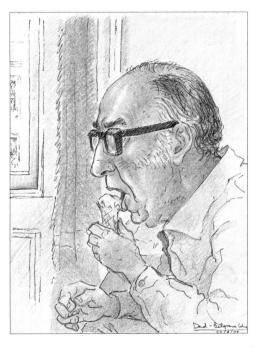

'Everything is politics these days', grumbled my father as he and my mother arrived at Heathrow last week for their annual visit, 'politics, politics'. He pronounces the word with a mixture of awe and distrust. That's how he was brought up. His father, Joel, seems not to have encouraged the children to ask any questions – either about their environment or even their own history. Joel did not arrive in South Africa as a colourful immigrant with a samovar under his arm and a folksong on his lips. He was a refugee from anti-semitic persecution determined to forget his previous life.

It has been a tough inheritance. The subject of 'politics' never cropped up round our dinner table, except for the passing reference to 'Bloody Communists!' At the time I couldn't have told you a single fact about Communism, although it was the most frightening word I knew. When I left South Africa in 1968, aged 19, I had never heard of Nelson Mandela, or the ANC, or the Sharpeville massacre. I wasn't aware that black mineworkers were forced to live apart from their families, wasn't even aware that blacks had to carry passes.

From 'South Africa's Chosen People', *Guardian*, 2 September 1988.

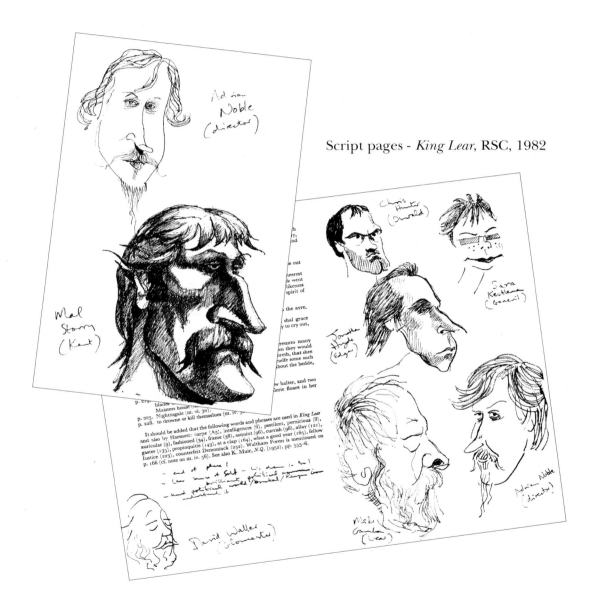

Script pages - *King Lear*, RSC, 1982

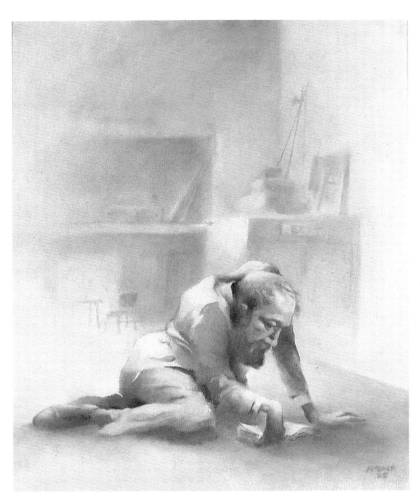

'Gambon rehearsing Lear', 1985

About half way through rehearsals, with me floundering around, Adrian Noble (the director) proposed a different kind of experimentation for the Fool, forgetting about the *man* for the moment and concentrating instead on his *job* – finding out what kind of entertainer he is. Adrian suggested investigating this through different devices on successive days – a red nose, a mask, a mime-artists's white face, and so on. We began with the red nose and never went any further. There is something very liberating about wearing a red nose, both externally and internally; you look, feel, and sound odd, exaggerated, caricatured. In a way, the red nose is the smallest version of the face mask, a device famous for its powers of releasing inhibition.

From *Players of Shakespeare, 2.*

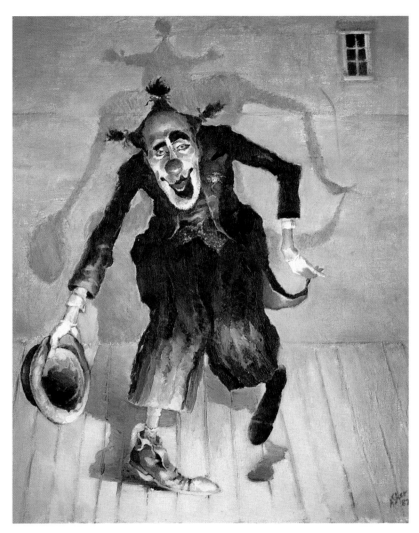

'The Fool', 1982

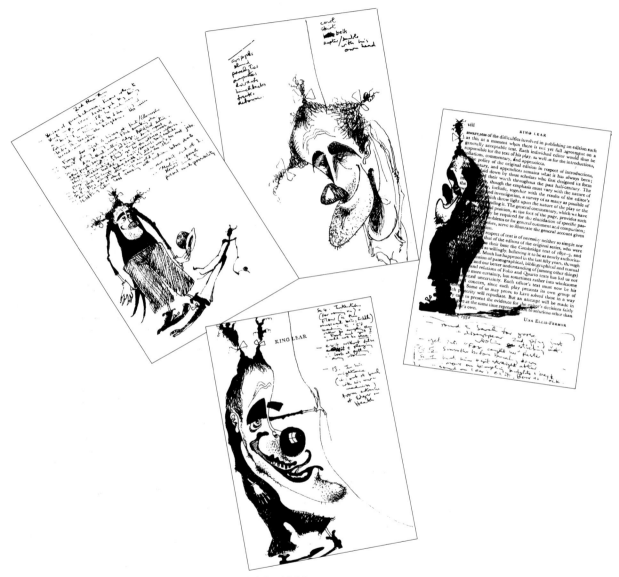

Script pages - *King Lear*, RSC, 1982

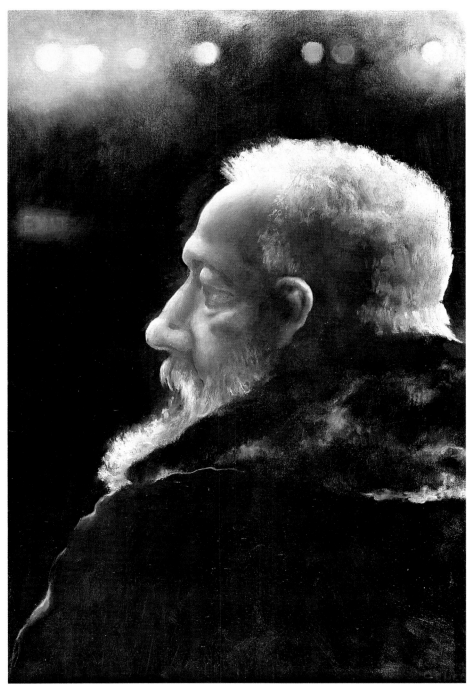

'Fool's Eye View of Lear', 1984

'Mark at Avonside', 1983

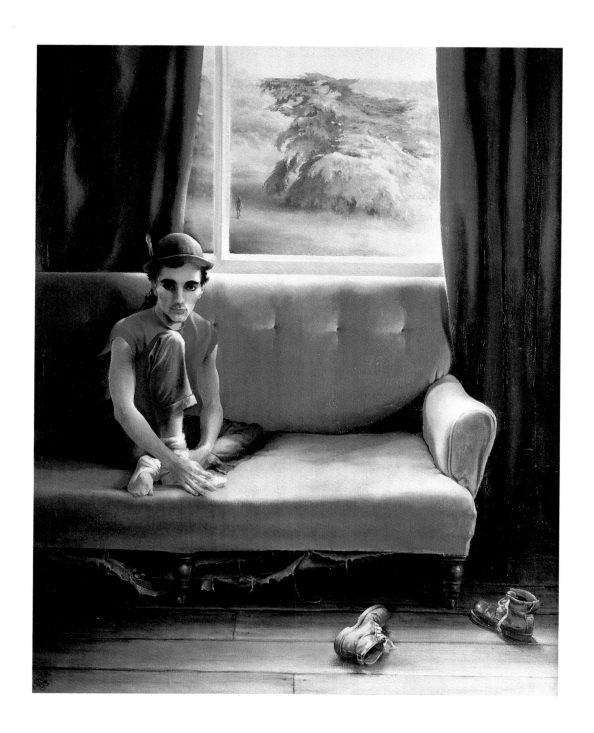

27

'Crossword Puzzle
(Highgate Ponds)', 1979

'Old Muscleman
(Highgate Ponds)', 1979

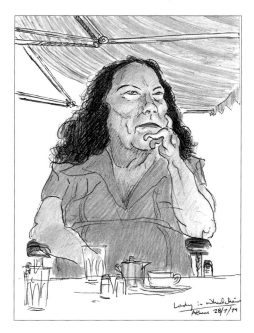

'Lady in Wheelchair,
Athens', 1979

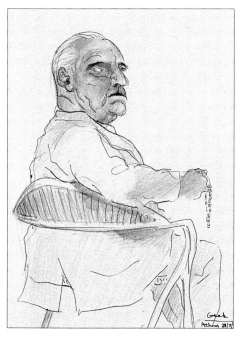

'Greek, Athens', 1979

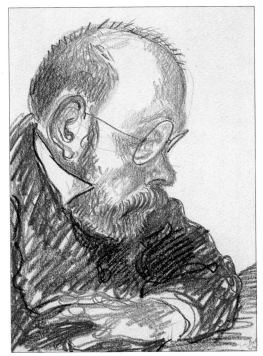

'Bob', 1980

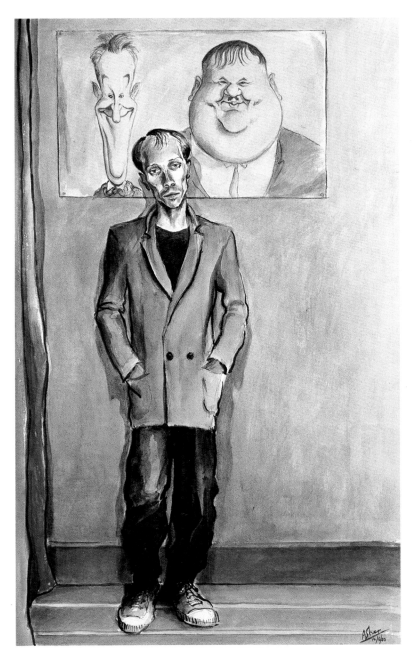

'Jim, Laurel and Hardy', 1980

December 1983: The Pit Theatre, Barbican.

There is a moment at the beginning of the show when Molière's troupe are posed on the upper level, frozen in the backstage frenzy before a curtain-call. On the back wall, little cardboard cut-out chandeliers light up through a red gauze, a sound effect of distant applause creeps in and a cello starts to play. It is a low-budget, small-stage compromise for Bulgakov's spectacular description: 'We can see the stage now from one of the wings. Candles burn brightly in the chandeliers – we can't quite see the auditorium, the nearest gilded box is empty, only sense the mysterious watchful blue haze of the half darkened theatre.' Quite a sad compromise really, but it always moves me. The tattiness and magic of theatre are very close.

January 1984 : BBC Studios, White City: Televising 'Tartuffe'.

Whereas in the theatre the whole scene just flits by (trousers down, trousers up, before you know it), in the studio they keep calling a halt and I'm left stranded on the table, exposed bum in the air, while technicians stroll around whistling, adjusting lights and camera angles. The make-up girl dashes in to touch-up the false tan on my nether cheeks. As she's bent over her task, I happen to burp violently.

> 'Oh, that's very nice', she says.
> 'You're lucky it didn't come out the other end.'
> 'I dunno. I've always wanted a parting in my hair.'

From *Year of the King.*

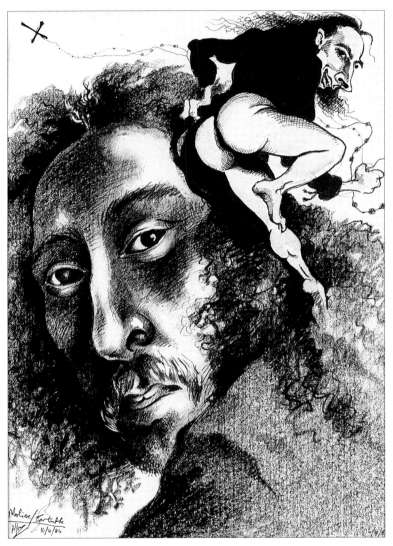

'Molière & Tartuffe', 1984

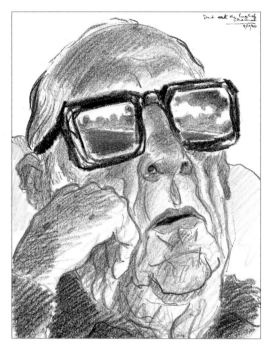

'Dad at the English Channel
(asleep)', 1980

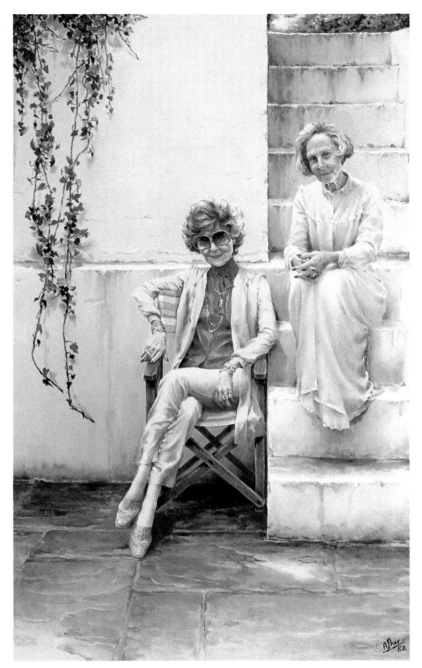

'My Mother; double portrait', 1982

Smous noticed that the Table Rock was flanked by two smaller peaks, set there as if to frame the astonishing view. The town was miniature by comparison, a white strip gleaming along the base, its buildings joined by the glare of the sun and then broken here and there by dark vegetation pouring down the slopes. Church bells rang out from a dozen directions and he listened, smiling, to the alien music looping over and under the roar of the wind.

From *Middlepost*.

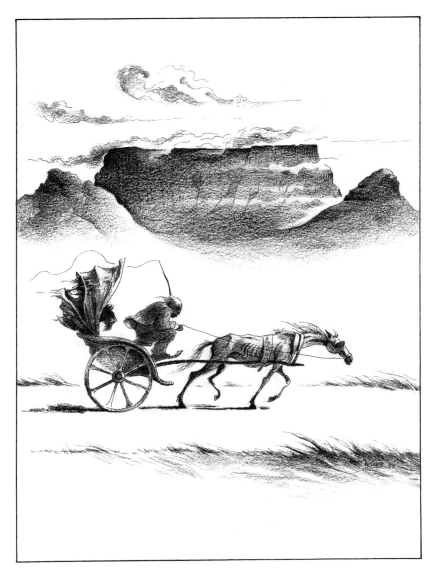

'Cape of Good Hope', 1988

'Lion's Head - view from Sea Point', 1983

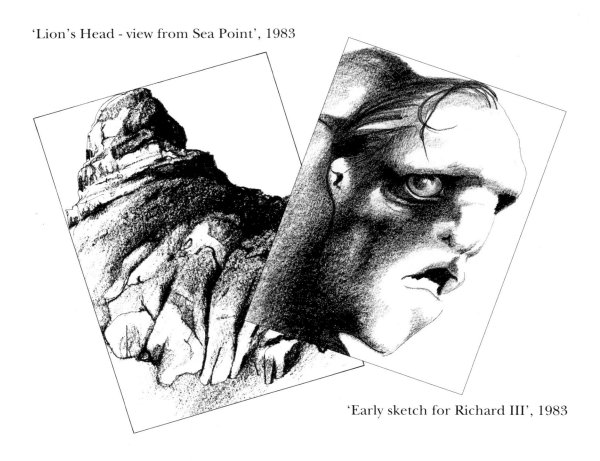

'Early sketch for Richard III', 1983

December 1983: Hermanus, Cape Province, South Africa

I sketch Richard III's head from this morning's thoughts. Interesting how the melting-pot works – the drawing has the bulk of Lion's Head; Klaus Kinski's eye; and a harelip from the Coetzee book I've been reading here, *Michael K.* Of course there's no way I could look like this. It would be very limiting to glue down so many of my features and wear so much prosthesis, for a part that long. But I love the thickness of this face; in a way, going back to the original Laughton image. With Brando's Godfather thrown in.

From *Year of the King.*

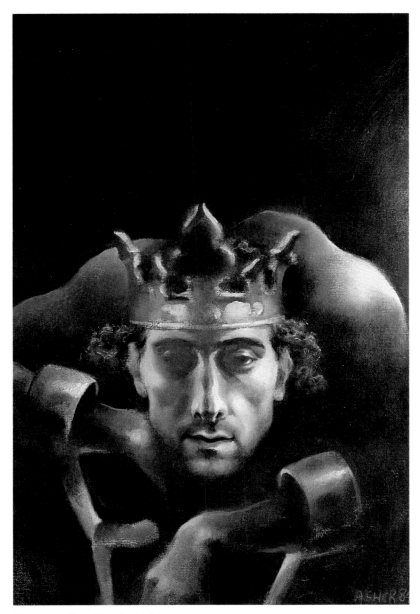

'Year of the King', 1984

'The Bottled Spider', 1984

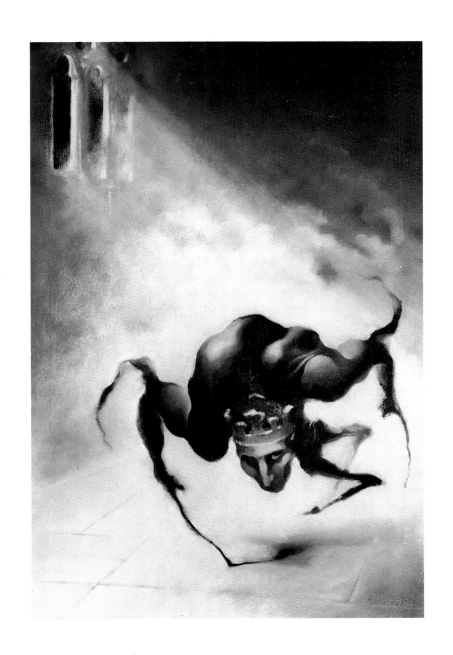

41

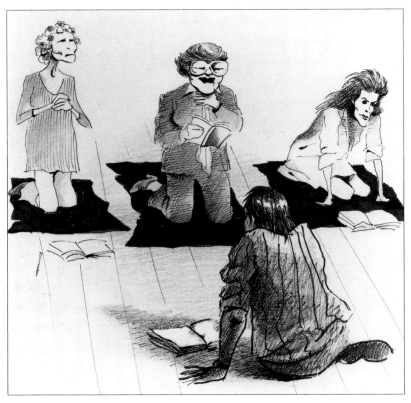

'Bill directing Richard III'
(from left to right: Yvonne Coulette, Pat Routledge, Frances
Tomelty, with Bill Alexander in the foreground), 1984

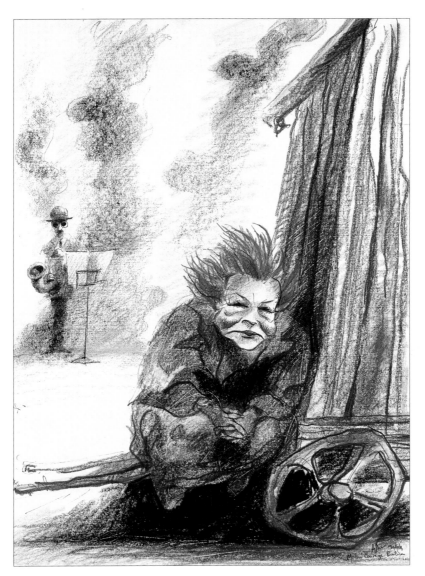

'Judi Dench as Mother Courage', 1984

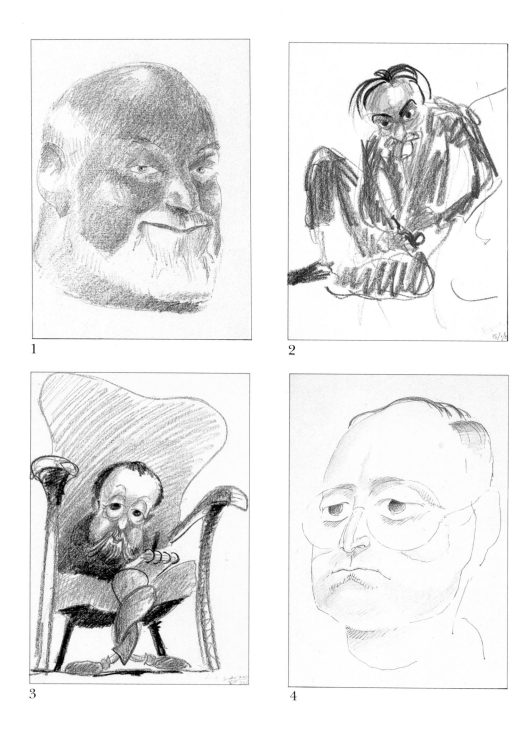

1

2

3

4

1. 'J.S.' (John Schlesinger), 1981

2. 'Athol Fugard', 1981

3. 'Another Session'
(Mike Leigh), 1980

4. 'Edward Bond', 1979

5. 'Terry Hands', 1984

6. 'Nigel Hawthorne', 1984

7. 'Memory of Harold Pinter', 1981

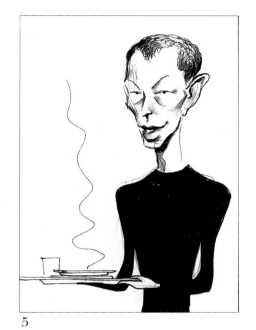

5

6

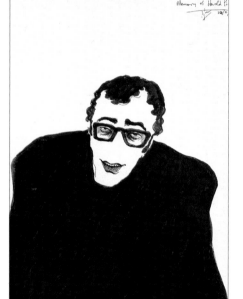

7

45

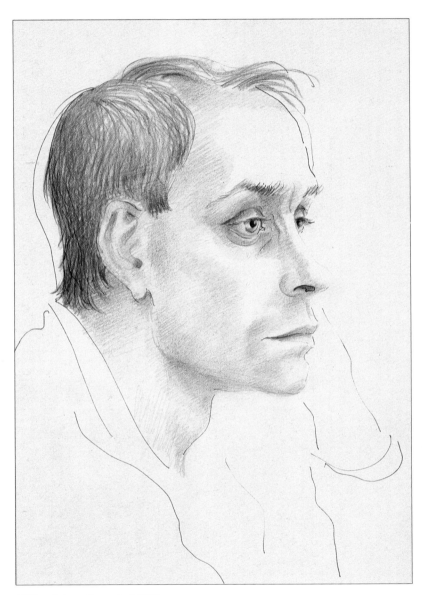

'Watching Juno', 1980

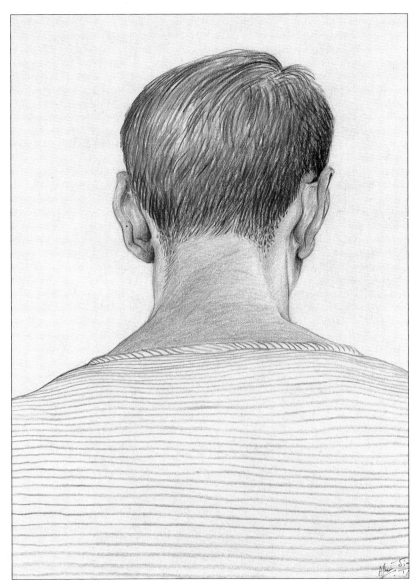

'Jimmy', 1980

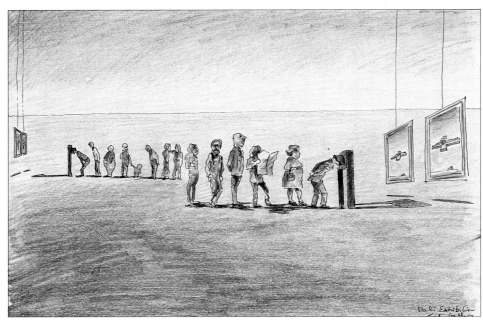

'Dali Exhibition, Tate Gallery', 1980

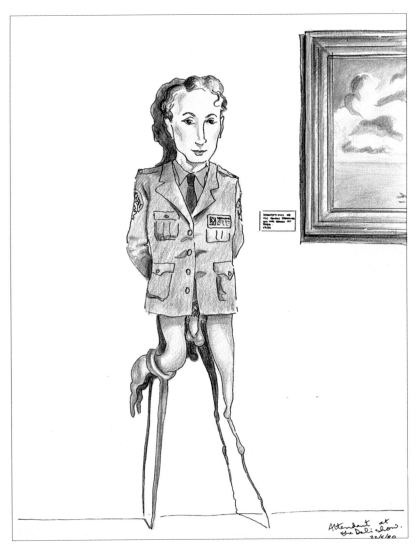

'Attendant at the Dali Show', 1980

Smous tried to make the appropriate gasps and grimaces of horror, but in vain. The book was too beautiful. Its crimson leather binding was not so much embossed as carved – you could dip your fingers into the furrows and hold the rises in your palm – which made the pages seem to swell beneath, and these were edged in a reddish gold, so that from the side the book looked like a chunk of brass. Elie stroked the Russian title. 'It's an unclean Bible,' he said, grinning in that way which had begun to frighten Smous, 'and it's yours,' then hurried from the bedroom. Again Smous searched for the terror he was supposed to feel, but again he failed, for now, flicking through the pages, which fell from the hand, thick and soft as cloth, he discovered the most astonishing thing – the Bible was illustrated.

From *Middlepost.*

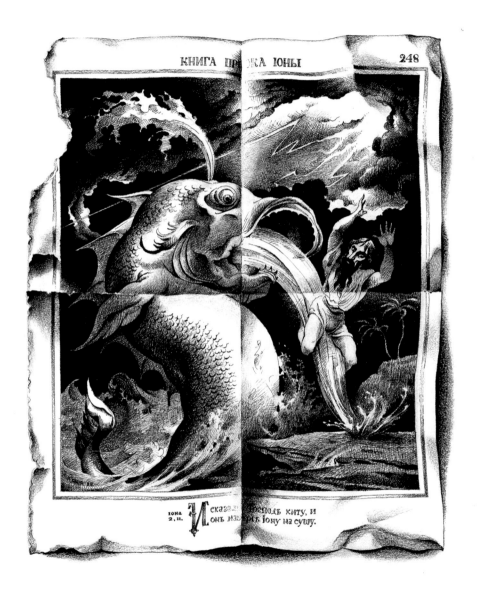

The page from the Russian Bible: 'The Great Fish Vomiting
Out Jonah Upon the Dry Land', 1988

WORD TOER IS IN JOU EIE LAND

During a visit to South Africa in 1983, I was flicking through a local magazine and came across this photo of an ostrich herd. I couldn't believe my eyes. For years I'd been trying to find a way of doing a particular painting — of a gay pub in Islington, with the men searching, but never making contact. The ostriches seemed to be doing the same thing : crowded together, but looking in different directions. The painting became "Only Connect" (opposite page), in memory of a friend, Drew Griffiths, who was murdered in 1984; a murder that's never been solved. When, a few years later, I was wondering how to do the jacket painting for "Middlepost" (see overleaf), the ostriches provided the solution again — this time their grouping was ideal for the characters in my story (the people of South Africa in 1902), with everyone speaking different languages, worshipping different gods, homesick for different places.

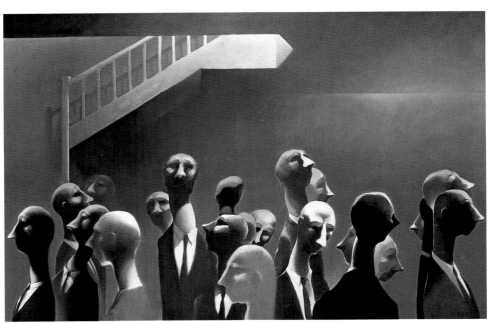

'Only Connect' (in memory of Drew Griffiths), 1985

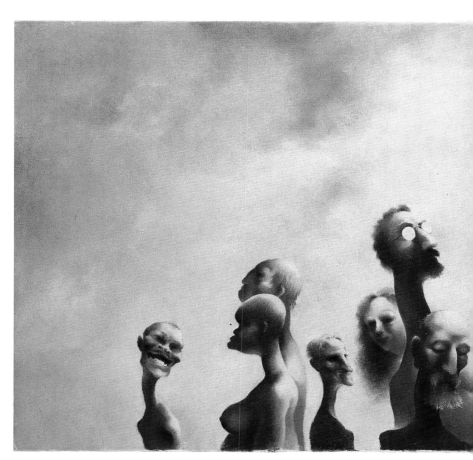

'Middlepost', 1988

54

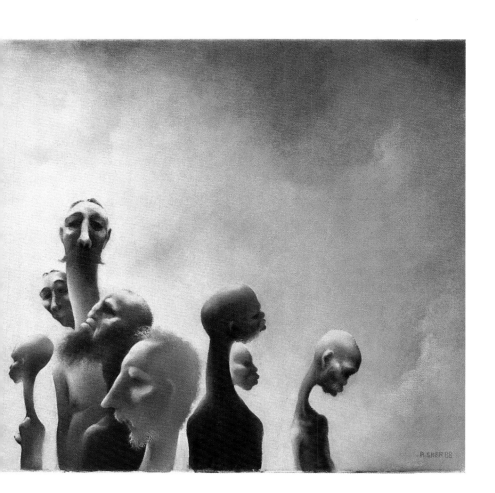

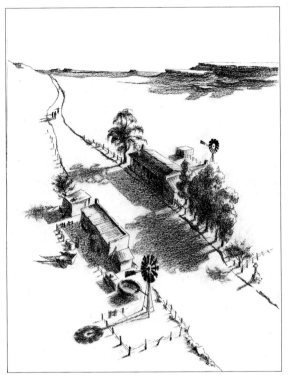

'Middlepost Part III',
1988

Middlepost was where we went for school holidays. A fleet of American limousines, Pontiacs, Chevrolets and Fords, would leave Cape Town before dawn, loaded with family, maids, pets and luggage. Never in the history of family outings have children asked 'How much further?' with more justification. At least half of the 250 mile journey was across semi-desert, hot, bumpy and boring. But eventually the cars began to climb what seemed like a vertical wall – Ganaga Pass – and suddenly you were a million times higher than before, the air was fresher and cooler. Soon Middlepost appeared, looking no bigger than a farm, the late afternoon sun stretching the shadows of trees and windmills, or catching on the corrugated iron roofs.

The Shers owned Middlepost. My father's brothers ran the small motel, bar, shop and petrol station. There was little else: a few homes, a blacksmith, a tiny primary school (whites only) and a police station.

From 'South Africa's Chosen People', *Guardian*. 2 September 1988.

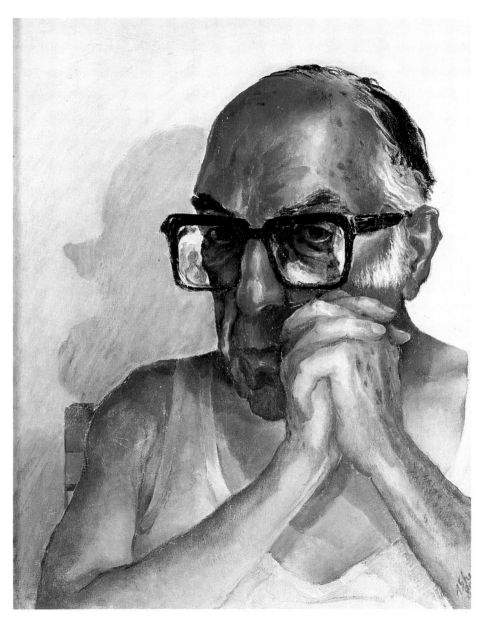

'The Skin and Hide Man', 1982

'Palm Tree, Nevis', 1985

'Rupert Graves', 1986

1-Mr Puff *(The Critic)*. 2-Henry V. 3-Hamlet. 4-Lear. 5-Macbeth. 6-James Tyrone *(Long Day's Journey Into Night)*. 7-Lord Olivier (on being introduced into the House of Lords). 8-Othello.
9-Archie Rice *(The Entertainer)*. 10-Richard III. 11-Maxim de Winter *(Rebecca)*. 12-Oedipus. 13-Romeo. 14-Edgar *(The Dance of Death)*. 15-Shylock. 16-Clifford Mortimer *(Voyage Round My Father)*. 17-Hotspur *(Henry IV, Part 1)*. 18-Dr Szell *(Marathon Man)*. 19-Coriolanus.

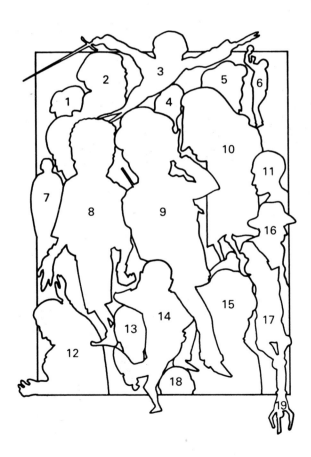

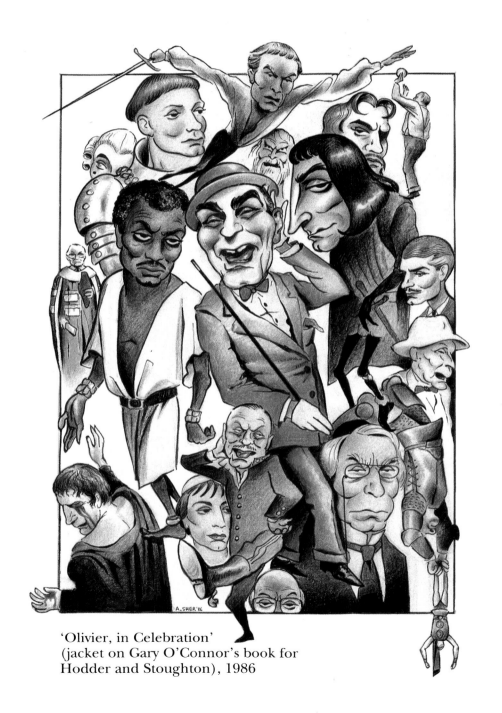

'Olivier, in Celebration'
(jacket on Gary O'Connor's book for
Hodder and Stoughton), 1986

'Torch Song Trilogy', 1989

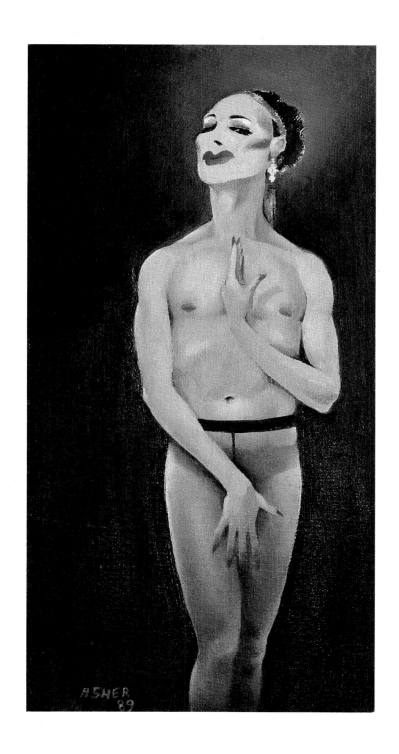

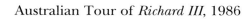

SUNDAY MAY 4:
Seal Bay. We were told we could walk among the animals on the beach, but were warned to do so very quietly and slowly since they can bite savagely. Needless to say the company charged down to the shore and proceeded to behave exactly as one would expect from a group of actors – shouting, laughing, doing seal impressions, etc. It seemed that I alone was heeding the advice of the tour guide as I moved among the mounds of kelp and basking seals very slowly and quietly. Suddenly an old sea-lion lunged at the nearest piece of human flesh – my bum, as it happens, which could not have been stiller or quieter at that moment since I was focusing my camera. I heard the company yell 'TONY, LOOK OUT!!', glanced round to see a massive bundle of iron-grey animal muscle and teeth rolling towards me, and sprang out of the way just in time to escape the endowment of a new disability on my Richard – that evil, hunchbacked, *single-buttocked* king.

From *The Times*, 29 July 1986.

TUESDAY 1 JULY:
There is the unexpected arrival of a Channel 4 film crew, who are making a documentary about the RSC. Suddenly there is a camera and microphone boom waiting around every corner: actors are filmed on the beach, putting their smalls into washing machines and drunk at the farewell party during the presentation of our joke awards, the Dicks-Down-Under.

From *The Times*, 31 July 1986.

THURSDAY 29 MAY:
Tonight the company was invited to Barry Humphries's new show *Tears Before Bedtime.* Humphries is a great hero of mine, but I was nervous that he would attempt to 'weave' me into the show. In the event he simply made some very funny references, like when Dame Edna was distributing the gladdies, she selected one with a bent stem and said 'Oh look possums, it's a Richard III gladdie!' The show was stunning as always and afterwards I went backstage and met Humphries for the first time. He told me that he'd liked the drawings in my book and that the Dame had whispered to him that she might consent to sit for a portrait sometime. She is always referred to in the third person, so one is left under the impression that this tall, restrained man all in black – sleek black hair, black polo-neck and slacks with bare feet sticking out – is simply as Dame Edna describes him, 'My little manager Barry Humphries', and that she herself is reclining in another, grander dressing-room.

From *The Times*, 30 July 1986.

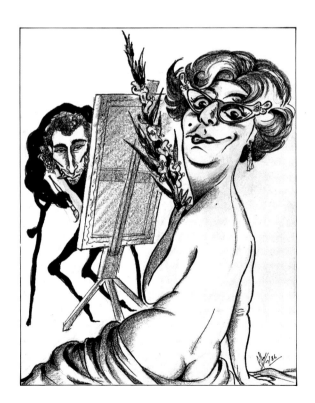

I started this painting in 1980, then abandoned it until this year. It's the subject matter — white South Africans — that makes me hesitate. On the one hand I can't help viewing them with astonishment: how relaxed they look, how safe; and the way they fool around with their white skins, darkening or lightening them with suntan or make-up. On the other hand, they're _my_ people and I fear for them. The lady in the middle is Esther Caplan, my drama/elocution teacher when I was a boy. She was a terrific teacher, very inspiring.

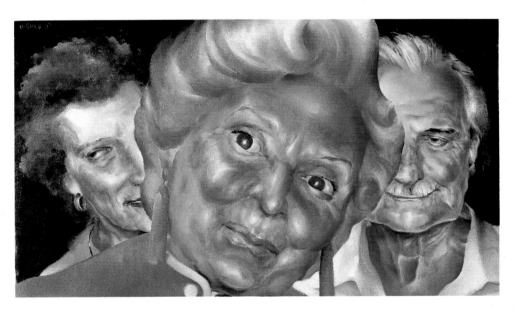

'White South Africans', 1980-89

'My Grandmother and other
South Africans', 1981

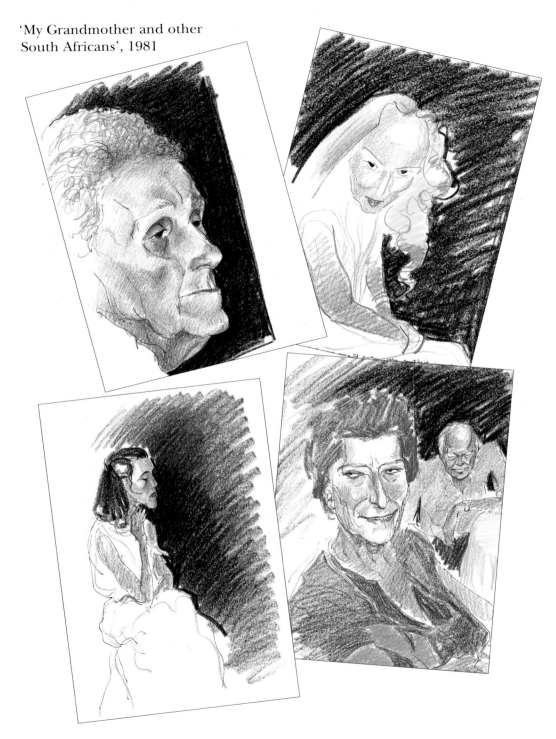

'Dad', 1980

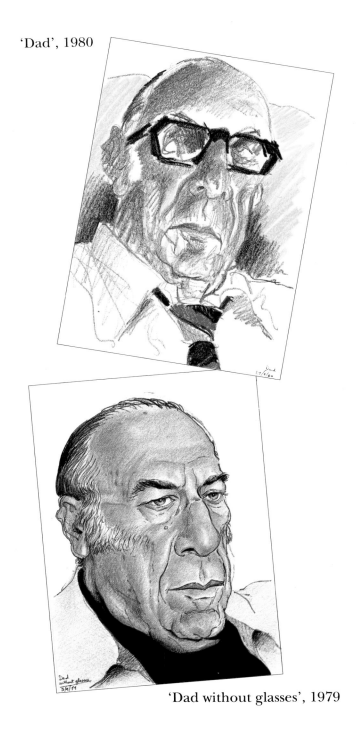

'Dad without glasses', 1979

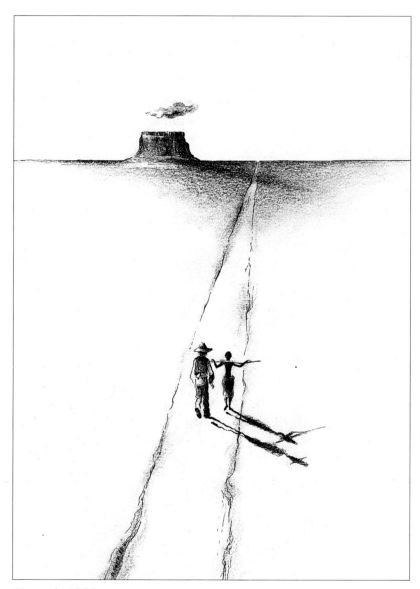

'Karoo', 1988

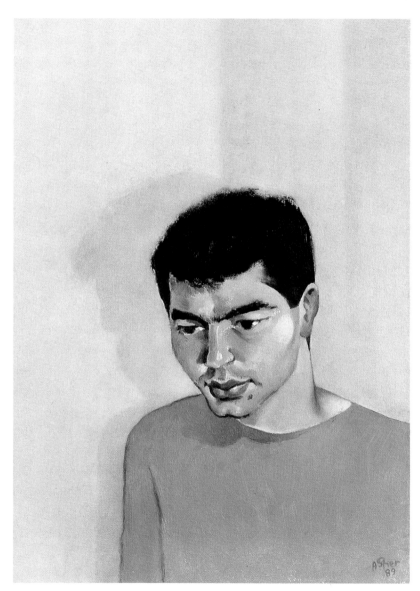

'Hüseyin in England', 1989

Quinn was careful to keep all trace of lust from his voice and eyes, retaining an expression of detached, erudite pleasure, hands gesturing now and then with classical grace. 'It is heavenly, you know,' he informed Smous, 'to be able to sit here and say these things to your face. That hairy face with its glorious organ of flesh sticking out, catching the light just so, its sheen neither slack nor rigid, a face altogether so reminiscent of the lower visage, the lap visage, the loin visage, with its own little terrier's crop and oh such expressive featurettes …'

From *Middlepost.*

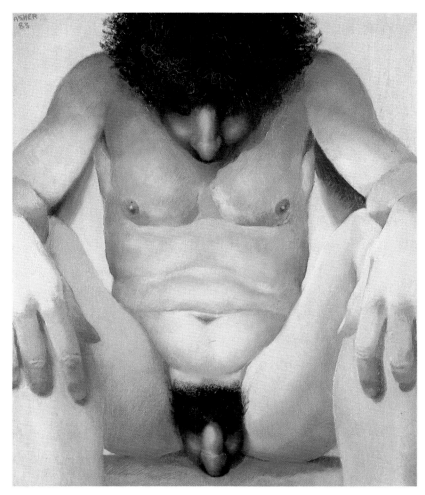

'Male; double portrait', 1983

Script pages - *Twelfth Night*, RSC, 1987

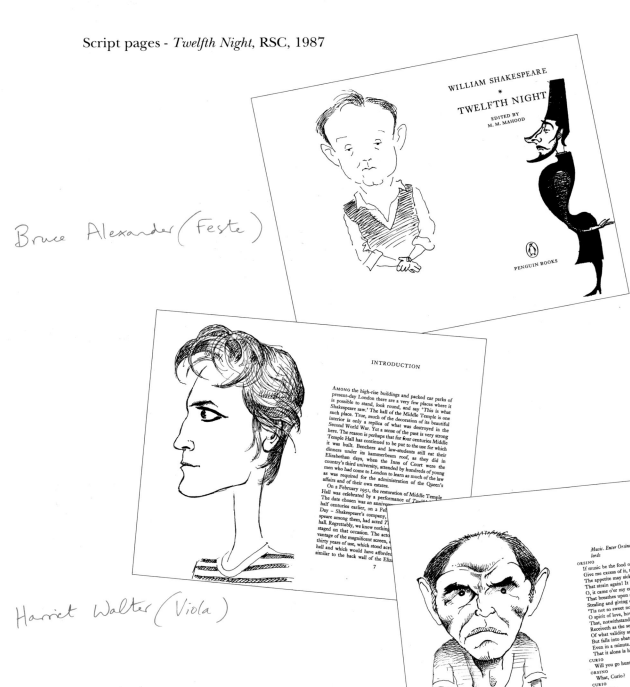

Bruce Alexander (Feste)

Harriet Walter (Viola)

Don Sumpter (Orsino)

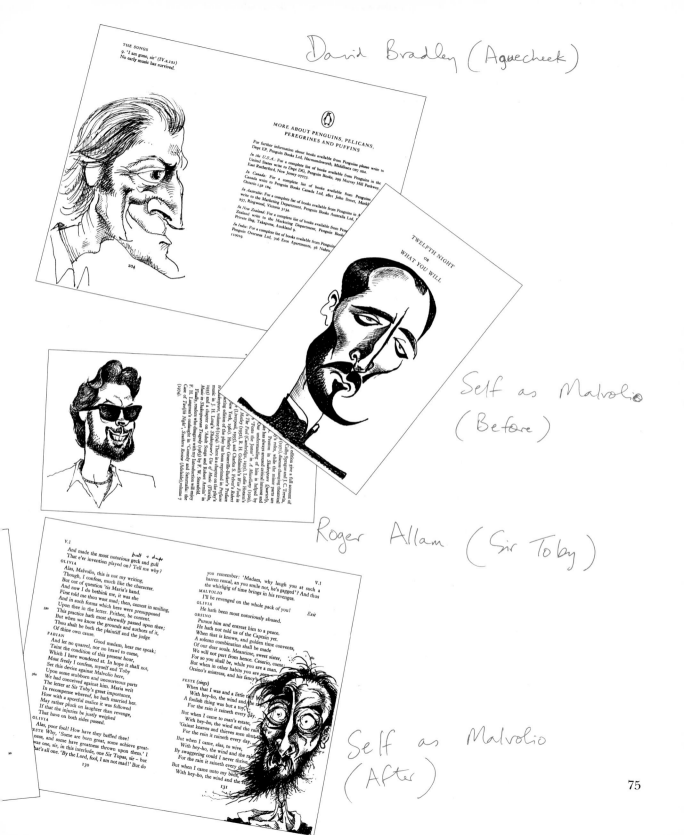

David Bradley (Aguecheek)

Self as Malvolio (Before)

Roger Allam (Sir Toby)

Self as Malvolio (After)

'Cox as Titus', 1989

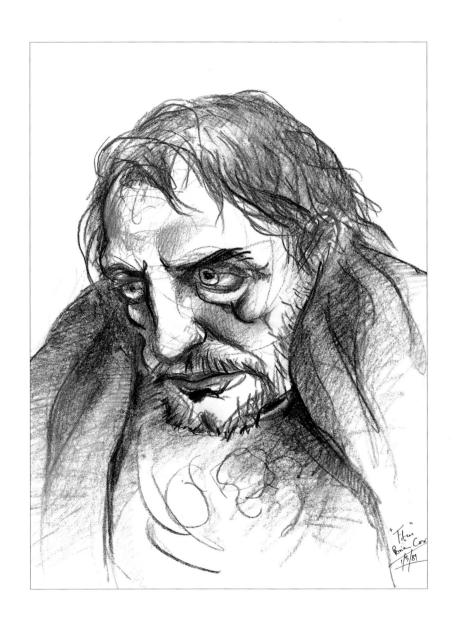

"Titus"
Brian Cox
1/3/89

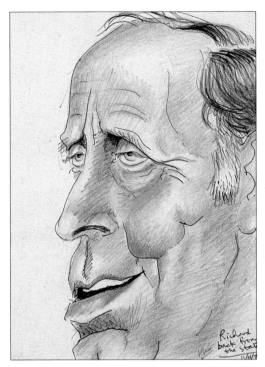

'Richard (Wilson)
back from the States', 1979

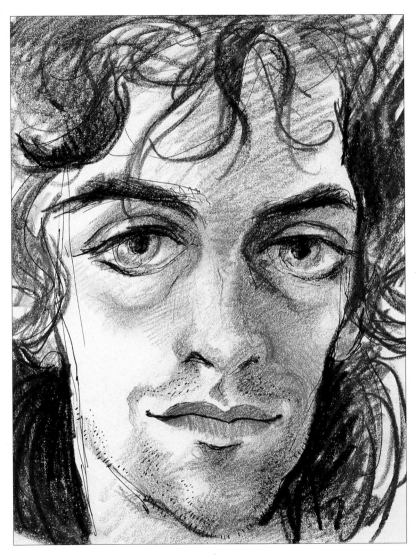

'Greg' (Gregory Doran), 1987

These days I am also working with the BDAF (British Defence and Aid Fund for Southern Africa) helping to organise an evening of South African music and writing, *Two Dogs and Freedom*, at Sadler's Wells in October. For the first time in my life I am meeting a whole group of South African exiles, black poets and writers like Mongane Serote and Mandla Langa, as well as the tireless Ethel de Keyser, who runs BDAF. She is another Jewish South African, sister of the freedom fighter Jack Tarshish. It is moving to hear their stories, so different from my own. Yet, the more I learn, the more I am also moved by my family's dilemma. Should they pack their bags and flee again – as many of their friends have done – or should they stick it out, remaining loyal to the country that gave their parents refuge?

From 'South Africa's Chosen People', *Guardian*, 2 September 1988.

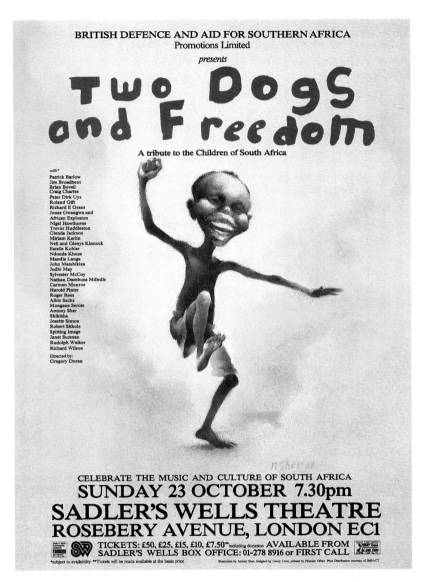

Poster, 1988

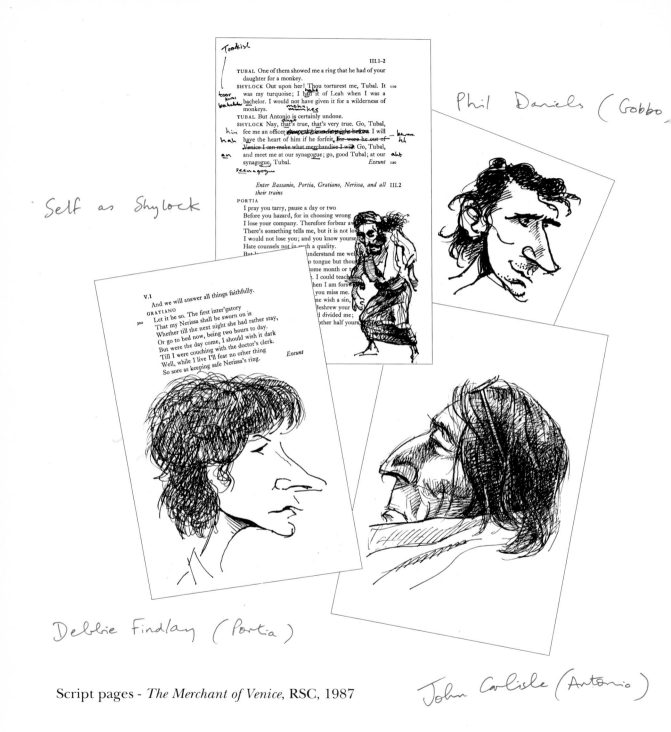

Toorkish

III.1–2

TUBAL One of them showed me a ring that he had of your
daughter for a monkey.

toor
kus
batalek

SHYLOCK Out upon her! Thou torturest me, Tubal. It 110
was my turquoise; I had it of Leah when I was a
bachelor. I would not have given it for a wilderness of
monkeys.

moh
munkies

TUBAL But Antonio is certainly undone.

hire

SHYLOCK Nay, that's true, that's very true. Go, Tubal,
fee me an officer ~~bespeak him a fortnight before~~ I will

berne
hh

hah

have the heart of him if he forfeit. ~~For were he out of~~
~~Venice I can make what merchandise I will~~ Go, Tubal,

an

and meet me at our synagogue; go, good Tubal; at our

aht

synagogue, Tubal. Exeunt 120

seenagogu

Enter Bassanio, Portia, Gratiano, Nerissa, and all III.2
their trains

PORTIA

I pray you tarry, pause a day or two
Before you hazard, for in choosing wrong
I lose your company. Therefore forbear aw
There's something tells me, but it is not lov
I would not lose you; and you know yourse
Hate counsels not in such a quality.
But l........understand me well
.....o tongue but thou
.....ome month or t
.....I could teach
.....hen I am forsw
.....you miss me.
.....me wish a sin,
.....Beshrew your
.....d divided me;
.....ther half yours

V.1

And we will answer all things faithfully.

GRATIANO

Let it be so. The first inter'gatory
300 That my Nerissa shall be sworn on is
Whether till the next night she had rather stay,
Or go to bed now, being two hours to day.
But were the day come, I should wish it dark
Till I were couching with the doctor's clerk.
Well, while I live I'll fear no other thing
So sore as keeping safe Nerissa's ring.

Exeunt

Self as Shylock

Phil Daniels (Gobbo,

Debbie Findlay (Portia)

John Carlisle (Antonio)

Script pages - *The Merchant of Venice*, RSC, 1987

82

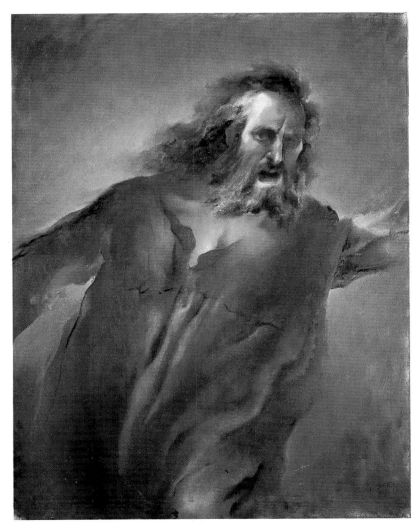

'Shylock', 1989

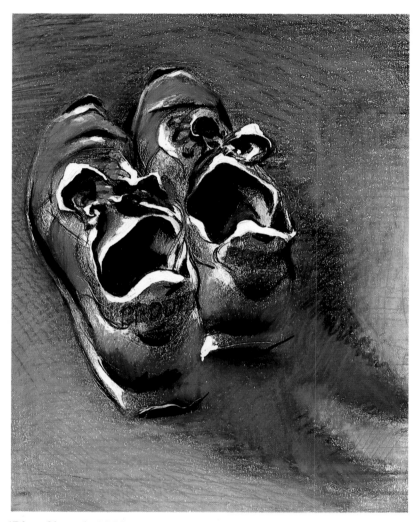

'Blue Shoes', 1986

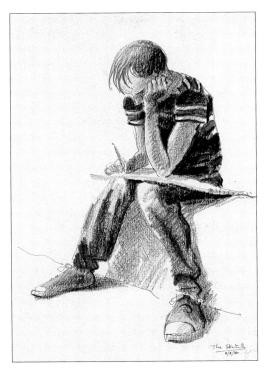

'The Sketch', 1980

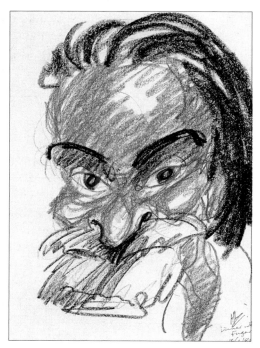

'Dinner with Fugard', 1981

JANUARY 16

I recall seeing the original 1965 production of 'Hello and Goodbye' in Cape Town with Fugard himself as Johnnie – a remarkable performance. At that time local theatre consisted of lightweight imports from London and Broadway, so Fugard's play about a reclusive, poor white man and his prostitute sister was like a blow to the face.

As a 16-year-old middle-class white, I blushed to hear stage characters talking in these ugly, street-wise accents – yet who would've thought there was so much energy and poetry there? Years later in London, when I finally met Fugard, I told him how momentous that evening had been. He would accept praise for the play, but not for his performance. Secretly I was pleased. If he didn't regard his own performance as definitive there was a chance for me. Johnnie is the first part I earmarked for myself.

From *The Times*, 23 August, 1988.

JULY 15
Today we work on the section we've called 'Amok', when Hester, or a force called Hurricane Hester, tears through 57A Valley Road, flinging around furniture, suitcases, boxes and finally me. Janice has often boasted how good she is at directing violent stage fights. I found this difficult to believe from one of life's natural teddy-bears – until today.

After several hours of her instructing Estelle on the best way to slap and pummel me, bite my neck, yank out my hair and kick in my guts, I start to wonder whether South Africa offers their theatre directors the same training facilities as their riot police?

From *The Times*, 24 August, 1988.

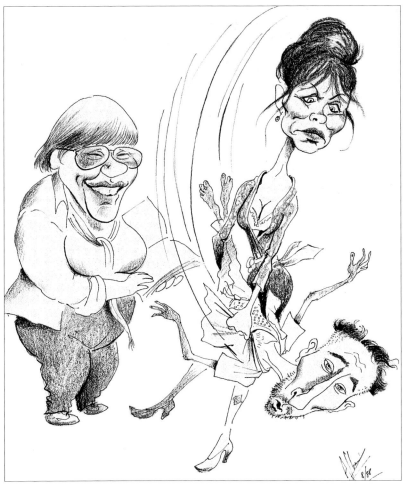

'*Hello and Goodbye* Rehearsal', (Janice Honeyman, the director, Estelle Kohler as Hester and self as Johnnie), 1988

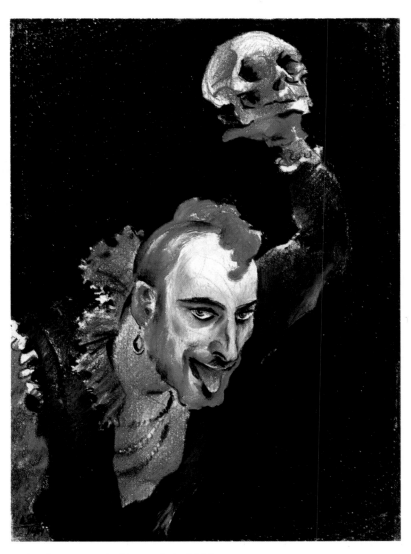

'The Revenger's Tragedy', 1989

As this book goes to print I'm about to start rehearsing a new Peter Flannery play, "Singer." Written in the Jacobean style (for the Swan Theatre) it shows what three men make of their lives after surviving a Nazi concentration camp. One, a Polish Jew called Singer, becomes a slum landlord in London. This drawing is how I might look as Singer...

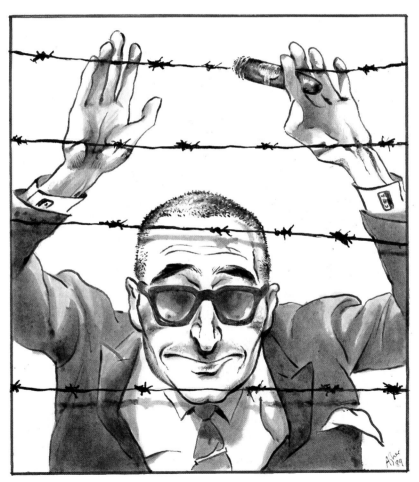

'Singer', 1989

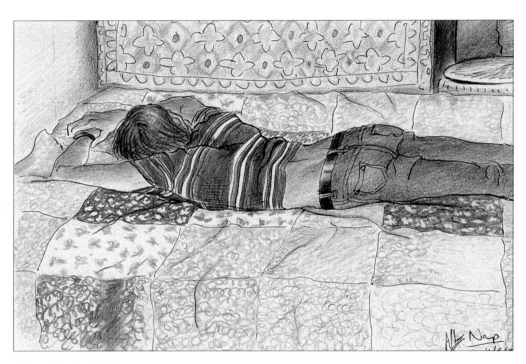

'The Nap', 1979

List of reproductions

Thanks are due to the following owners of pictures by Antony Sher for their helpful co-operation:- Eileen Allan, Jinder Bhalla, Cathy & Les Blair, The BDAF, Michael Coveney, Gregory Doran, Mr and Mrs Fellowes, Michal Friedlander, Anne Garwood, Giles Gordon, Rebecca Hall, Nick Hamm, Terry Hands, Robin Hooper, Mrs E.M. Horsley, Patricia Kennedy, Estelle Kohler, Gordon Newman, Angela Patmore, Jonathan Perry, Peter Postlethwaite, RSC Gallery, John Schlesinger, Margery Sher, Richard Wilson

Jeu de Paume, oils, 1983
Goose-Pimples, ink and crayon, 1981
Playing Howard Kirk, ink and coloured pencils, 1980
My Parents, watercolours, 1977
Hitler and the Mentally Ill, ink and crayon, 1984
Peter Sutcliffe, ink and crayon, 1984
Theatre Posters, 1974 and 1978
Barre, charcoal, 1971
Twins, watercolours, 1975
Drying Out, ink and coloured pencils, 1979
Actor Resting, oils, 1982
Backcloth for The Country Wife, 1974
The Russian Richard III, ink and coloured pencils, 1980
Olivier's Richard III (in a dream), ink and crayon, 1984
Calvinia, ink and crayon, 1988
Dad at Belgrave Gardens, ink and coloured pencils, 1979
Script pages from King Lear, ink, 1982
Gambon rehearsing Lear, oils, 1985
The Fool, oils, 1982
Script pages from King Lear, ink, 1982
Fool's Eye View of Lear, oils, 1984
Mark at Avonside, oils, 1983
Crossword Puzzle (Highgate Ponds), ink and coloured pencils, 1979
Old Muscleman (Highgate Ponds), ink and coloured pencils, 1979
Lady in Wheelchair (Athens), ink and coloured pencils, 1979
Greek (Athens), ink and coloured pencils, 1979
Bob, crayons, 1980
Jim, Laurel and Hardy, watercolours, 1980
Molière and Tartuffe, ink and crayon, 1984
Dad at the English Channel, crayons, 1980
My Mother; double portrait, oils, 1982
Cape of Good Hope, ink and crayon, 1988
Lion's Head – view from Sea Point, ink and crayon, 1983
Early Sketch for Richard III, ink and crayon, 1983
Year of the King, oils, 1984
The Bottled Spider, oils, 1984
Bill directing Richard III, ink and crayon, 1984
Judi Dench as Mother Courage, ink and crayon, 1984

'J.S.' (John Schlesinger), crayons, 1981
Athol Fugard, crayons, 1981
Another Session (Mike Leigh), crayons, 1980
Edward Bond, ink and coloured pencils, 1979
Terry Hands, ink and crayon, 1984
Nigel Hawthorne, ink and crayon, 1984
Memory of Harold Pinter, ink, 1981
Watching Juno, ink and coloured pencils, 1980
Jimmy, ink and coloured pencils, 1980
Dali Exhibition, Tate Gallery, ink and crayon, 1980
Attendant at the Dali Show, ink and coloured pencil, 1980
The page from the Russian Bible, ink and crayon, 1988
Only Connect, oils, 1985
Middlepost, oils, 1988
Middlepost, Part III, ink and crayon, 1988
The Skin and Hide Man, oils, 1982
Palm Tree, Nevis, ink and crayons, 1985
Rupert Graves, ink and crayons, 1986
Olivier, in Celebration, ink and coloured pencil, 1986
Torch Song Trilogy, oils, 1989
Australian Tour of Richard III, ink and crayon, 1986
White South Africans, oils, 1980-89
My Grandmother and other South Africans, ink and crayon, 1981
Dad, crayons, 1980
Dad without glasses, ink and coloured pencils, 1979
Karoo, ink and crayon, 1988
Hüseyin in England, oils, 1989
Male; double portrait, oils, 1983
Script pages from Twelfth Night, ink, 1987
Cox as Titus, ink and crayon, 1989
Richard Wilson, ink and coloured pencils, 1979
Greg (Gregory Doran), ink and crayons, 1987
Poster, 1988
Script pages from The Merchant of Venice, ink, 1987
Shylock, oils, 1989
Blue Shoes, ink, crayon and Tippex, 1986
The Sketch, crayons, 1980
Dinner with Fugard, crayons, 1981
Hello and Goodbye Rehearsal, ink and crayon, 1988
The Revenger's Tragedy, ink and crayons, 1989
Singer, ink, 1989
The Nap, ink and coloured pencils, 1979